PTSD

in Pictures & Words

by Clyde R. Horn

PTSD in Pictures & Words

© 2011 Clyde R. Horn, Veteran/Photographer

ISBN: 978-1-61170-055-8

Photographs by Clyde R. Horn

Printed in the USA and UK on acid-free paper.

To purchase additional copies of this book go to:
www.rp–author.com/horn

Robertson Publishing™
59 North Santa Cruz Avenue
Los Gatos, California 95030 USA
www.RobertsonPublishing.com

Choppers in formation, Vietnam 1968

FEB 68

Dedicated to my art therapist extraordinaire:

Andrea Brandom, MA, ATR-BC. Veteran's Administration San Jose, California.

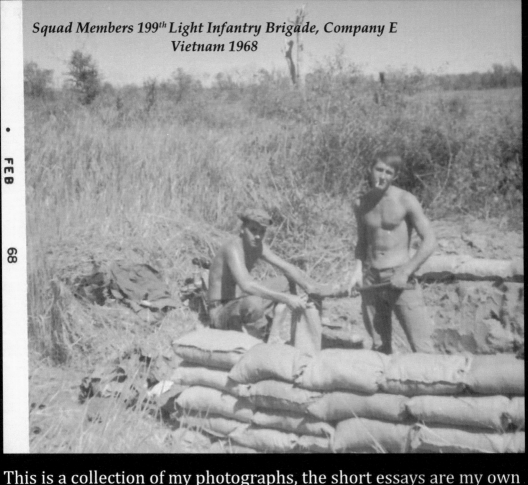

Squad Members 199ᵗʰ Light Infantry Brigade, Company E
Vietnam 1968

This is a collection of my photographs, the short essays are my own thoughts and words.

This book is intended to address Veterans of all wars, conflicts and trauma—a book without technical terms and language.

As a combat veteran of the Vietnam War I also suffer from PTSD (Post Traumatic Stress Disorder). I understand the debilitating effects and the struggle many veterans experience with this terrible disorder.

May this book bring comfort, understanding and hope to all those who suffer from the trauma associated with service-connected disabilities.

Sincerely,

Sgt. Clyde R. Horn

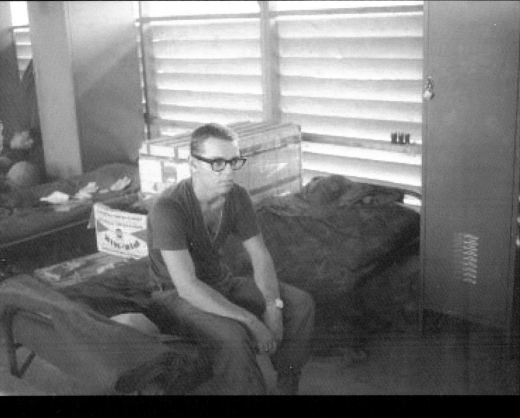

WHAT IS POST-TRAUMATIC STRESS DISORDER?

An article in military.com on May 30, 2011 gives a good simple definition of post-traumatic disorder (PTSD).

Symptoms can include:
- nightmares
- feeling numb
- having difficulty experiencing love or closeness with others
- feeling jittery or overly alert
- having difficulty sleeping
- experiencing anger or irritability
- having difficulty concentrating
- substance abuse problems
- having feelings of despair or hopelessness

My experience was Vietnam but soldiers of all wars have suffered significantly from this terrible disorder. Refer to the National Center for PTSD webpage for more technical information.

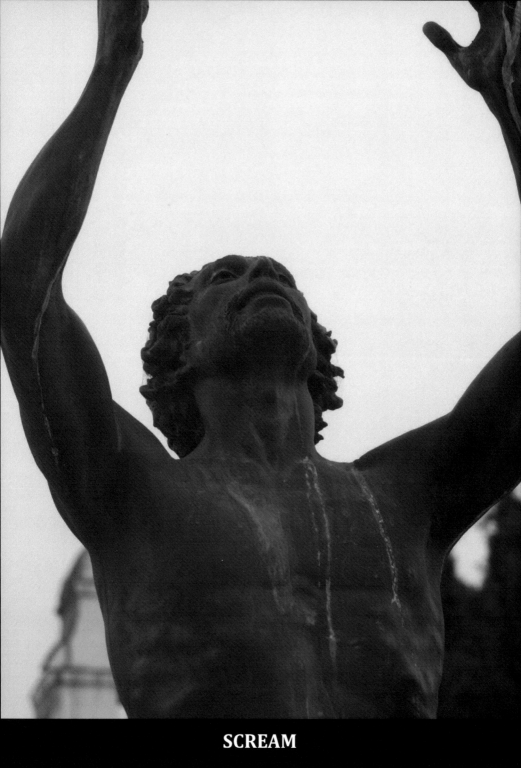

SCREAM

I YELL TO THE HEAVENS, I LIFT UP MY ARMS AND WAIL, I SCREECH
IN PAIN...

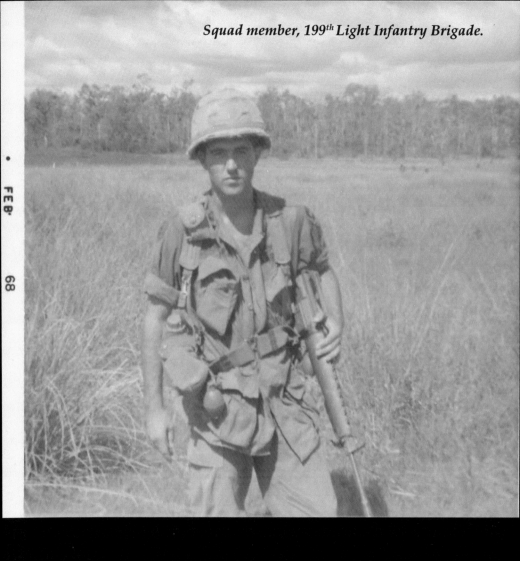

Squad member, 199th Light Infantry Brigade.

FEB 68

I CAN'T REMEMBER HIS NAME

One of the issue's of PTSD is forgetting names of soldiers we fought along side in life and death situations.

Trauma can wipe out memory, so many veterans have guilt feelings over this loss.

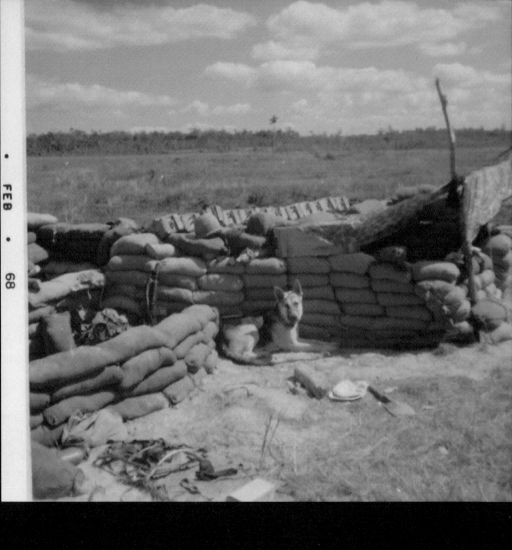

German Shepherd trained to detect booby traps
in rice paddies around Saigon.

I try to hear words but they bounce off my ears failing to penetrate.

I am a rock with the waves crashing down on me.

I am etched by the constant pounding of those trying to get in.

How desperately I want to let them in but can't figure out how...
YET.

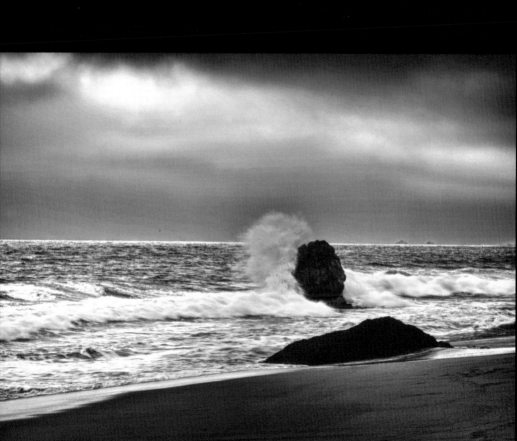

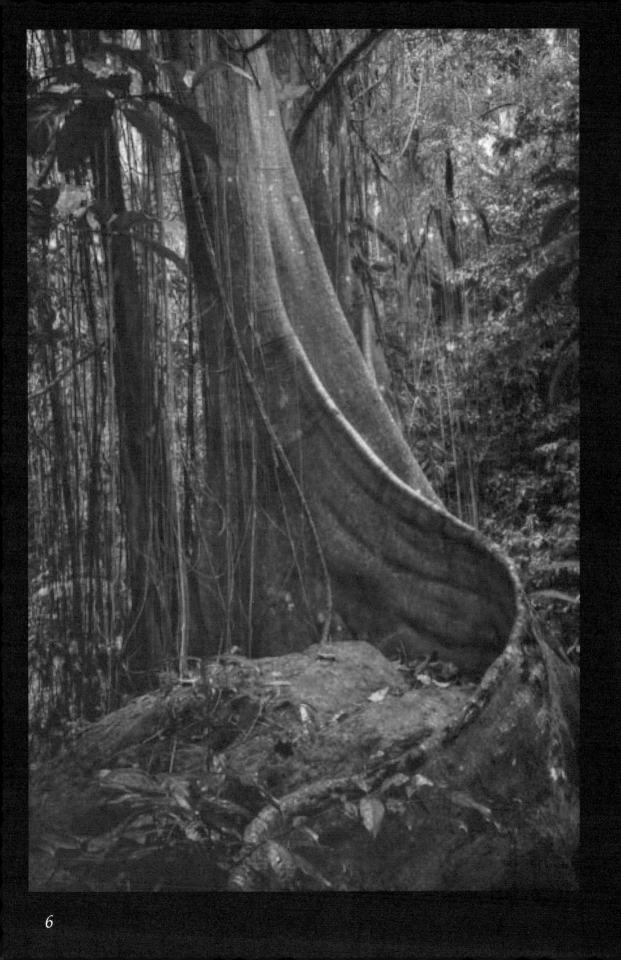

PRIMAL

Grunting, scratching, clawing being ever aware of deep rumblings within the primitive part of my brain.

I'm a dinosaur, a relic ever ready to fight or flee.

I'm on alert even when I sleep. I'm a huge force full of pent-up energy needing relief—sweet, rational, grounded and caring relief.

DARE you approach me taking the chance…risking yourself because you just can't know what will happen?

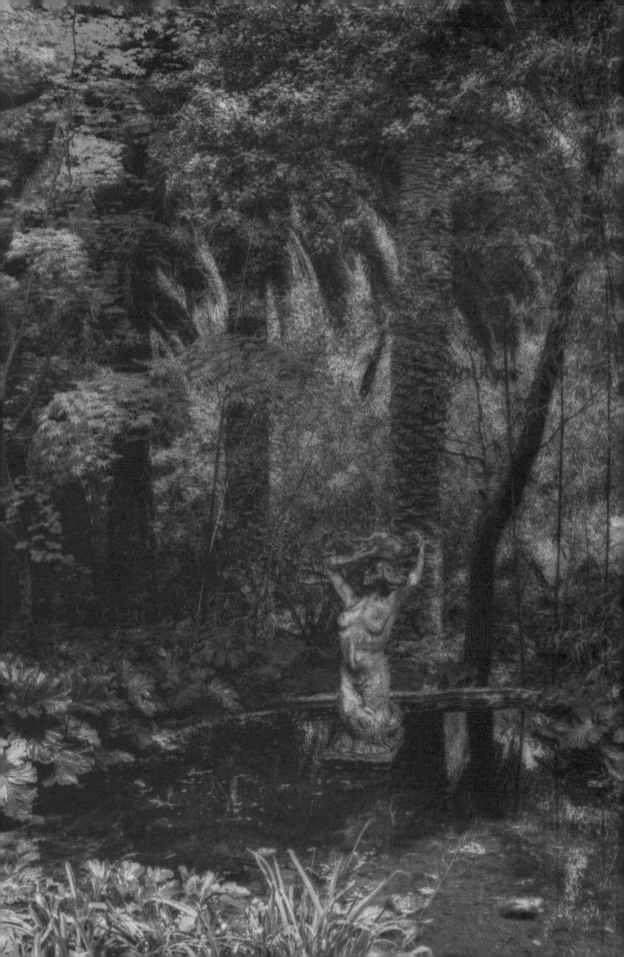

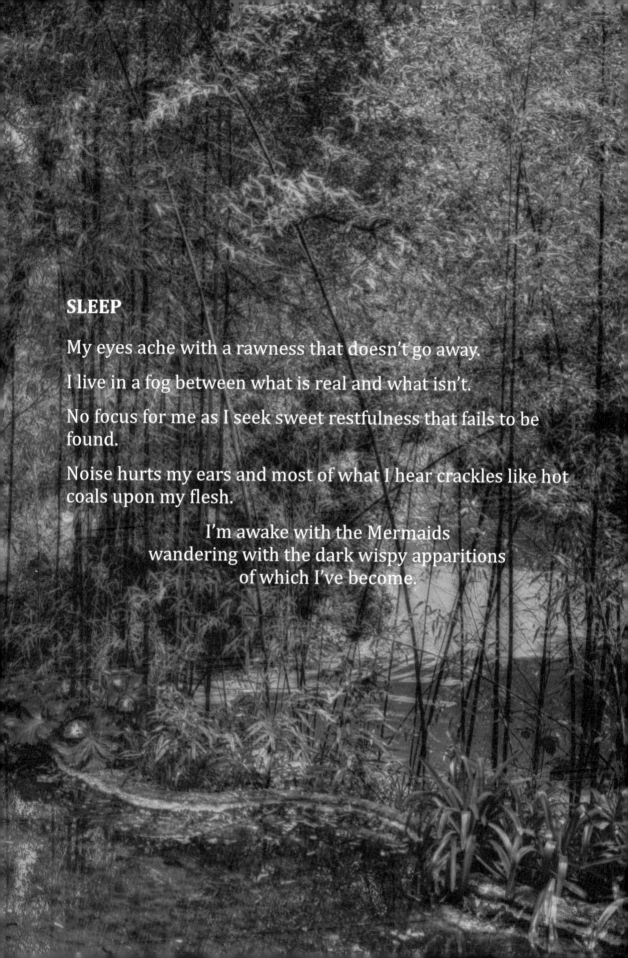

SLEEP

My eyes ache with a rawness that doesn't go away.

I live in a fog between what is real and what isn't.

No focus for me as I seek sweet restfulness that fails to be found.

Noise hurts my ears and most of what I hear crackles like hot coals upon my flesh.

I'm awake with the Mermaids
wandering with the dark wispy apparitions
of which I've become.

"DID you ever kill anyone?" is the most absurd question asked of a soldier.

War is death with killing as a part of it.

If you believe everything is connected as I do than being part of a nation that goes to war means YOU were a part of it too.

However, I'm the one who sees death in my dreams because I was there.

You should thank me.

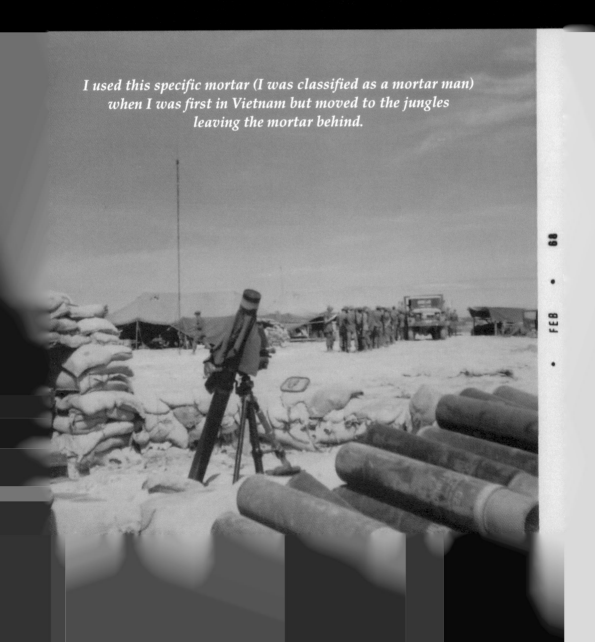

I used this specific mortar (I was classified as a mortar man)
when I was first in Vietnam but moved to the jungles
leaving the mortar behind.

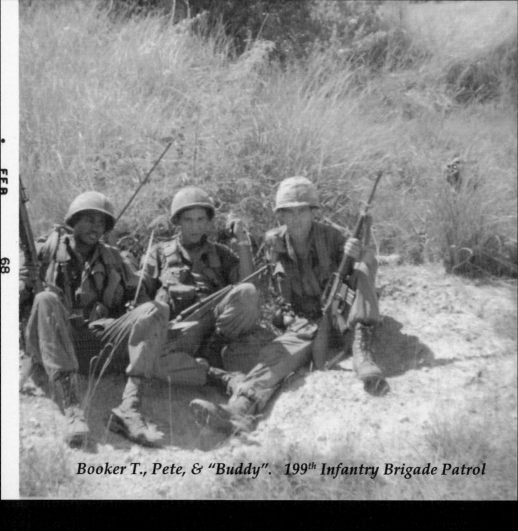

Booker T., Pete, & "Buddy". 199th Infantry Brigade Patrol

TAKING A BREAK

The 199th was a combat ready unit.

We traveled in helicopters all over Vietnam.

We were dropped off in remote area's for "search and destroy" missions.

Usually we would set up a base camp, if we could, in open area's rather than in the jungle.

If the enemy came toward us we had some visibility prior to engagement.

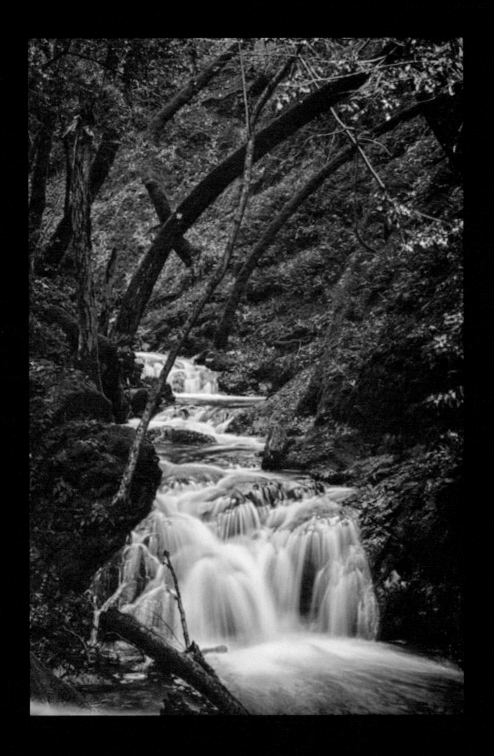

INCONGRUENCE

Rustling brooks, beautiful flora and fauna, rain forest with wonders of nature—on the lookout for someone who wants to kill me.

ANIMAL

I'M AN ANIMAL surviving by stealth, silence, cunningness and speed.

I slip through life unseen...looking, searching, starving and listening.

I'm on alert, roving past the presence captured by the past.

I'm invisible even to myself.

ALONE

FLYING through the storm my wings light up, the thunder claps
around me, I soar but I'm alone...so alone.

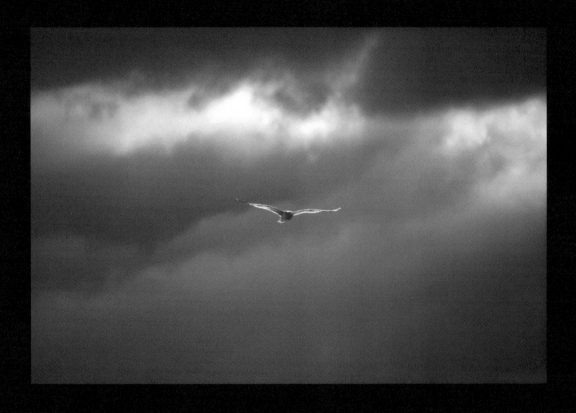

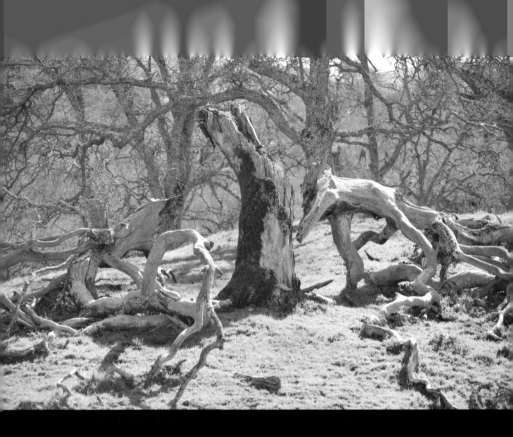

BROKEN

EVERY PIECE OF ME seems torn to shreds. Pain permeates my soul. I hate the pervasiveness of torture that engulfs me.

Every part of my body screams out, "When will this end?"

'How can I find peace?"

'When, if ever, will my soul settle down?"

'I'm living hell on earth."

'Please, oh please, take this pain away."

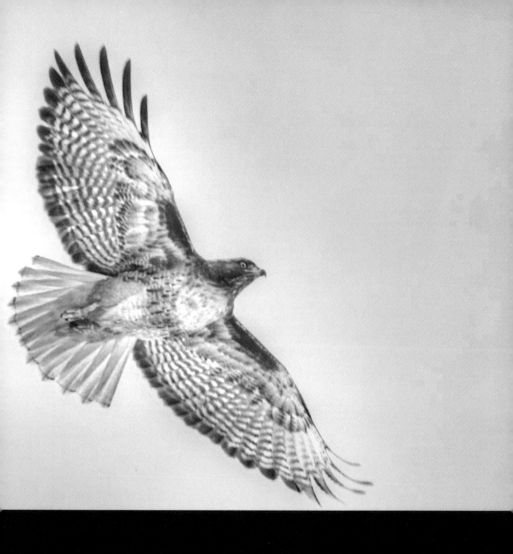

THE HAWK

The hawk glides with the thermals looking down upon the earth for
prey. It has penetrating eyes that can spot the slightest movement.

It appears so unassuming high in the heavens.

Suddenly it explodes reaching incredible speeds and plucks its prey

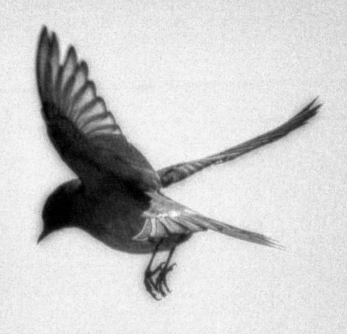

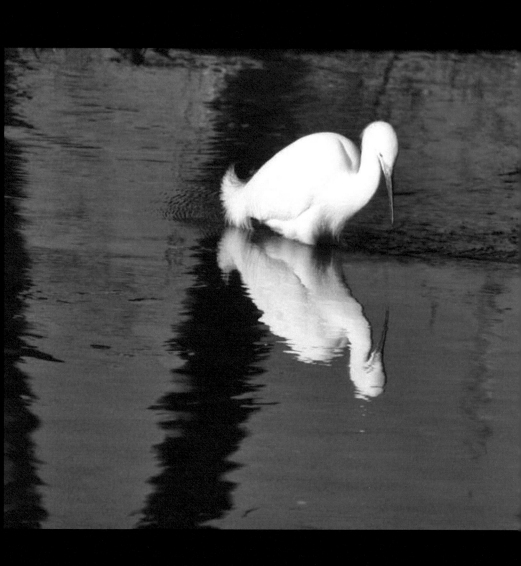

REFLECTION

Am I looking at me, in me, or through me?

it with all the bridges we have to cross in this life? D
ough to worry about without having to wonder what
er side?

so much energy to make decisions. I don't want to fa
 choice.

Please, just let me stay where I am.

ll me what to do. Give me the answers. Prescribe a p

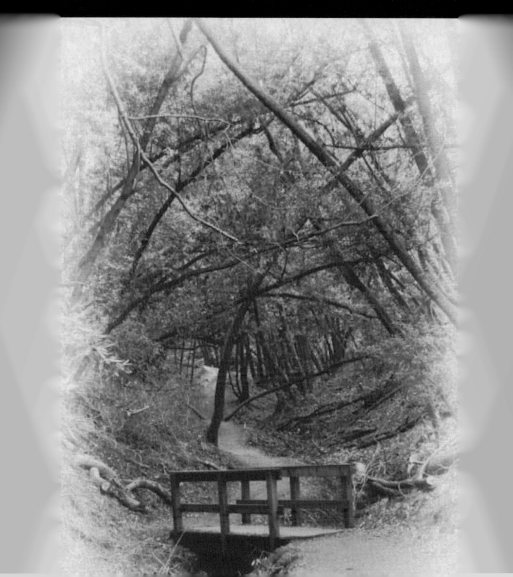

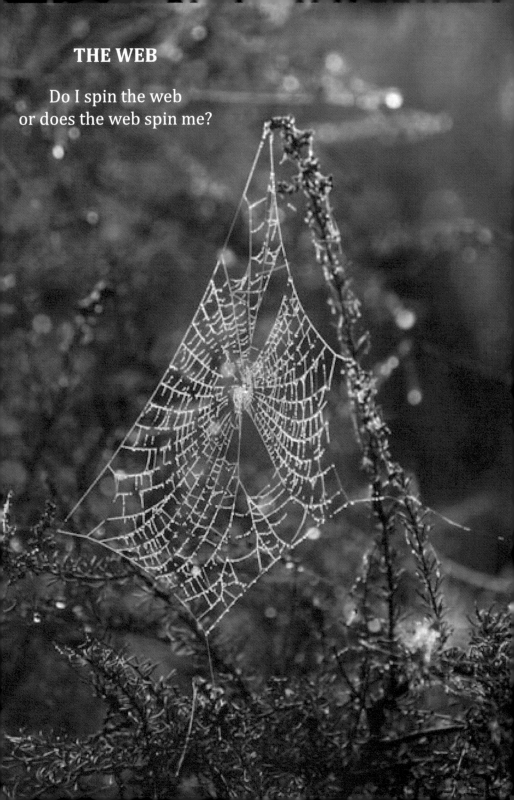

THE WEB

Do I spin the web
or does the web spin me?

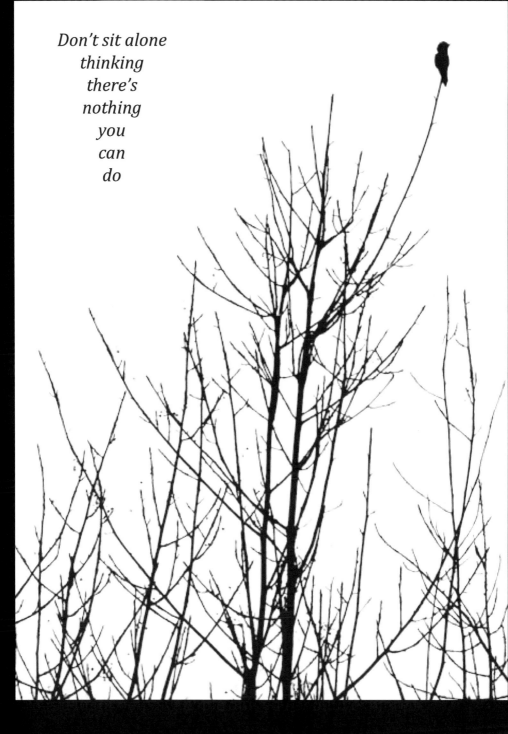

*Don't sit alone
thinking
there's
nothing
you
can
do*

ALONE

I didn't know I could receive benefits from the VA until I explored the issue 40 years after my combat experience.

There is a lot of help available and you should explore it.

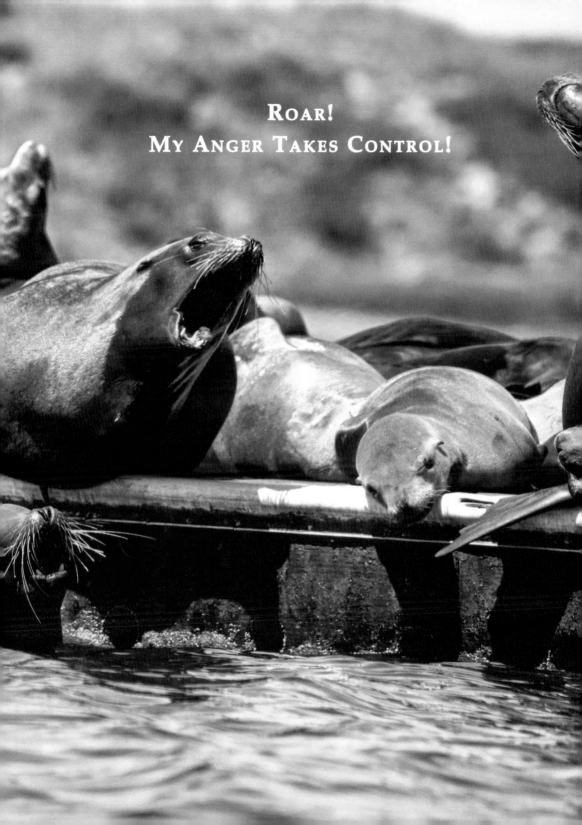

ROAR!
MY ANGER TAKES CONTROL!

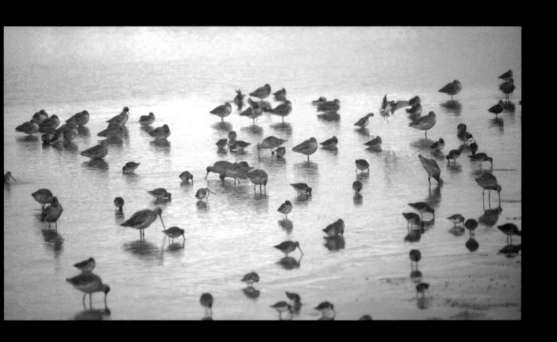

HELP

THERE are a lot of us around. We pick at this and that.

We are among many but stand by ourselves.

A few stand out but most of us are in the background
among the gray areas.

We survive but sometimes just barely.

We need help.

The hard part is not asking for it but getting it.

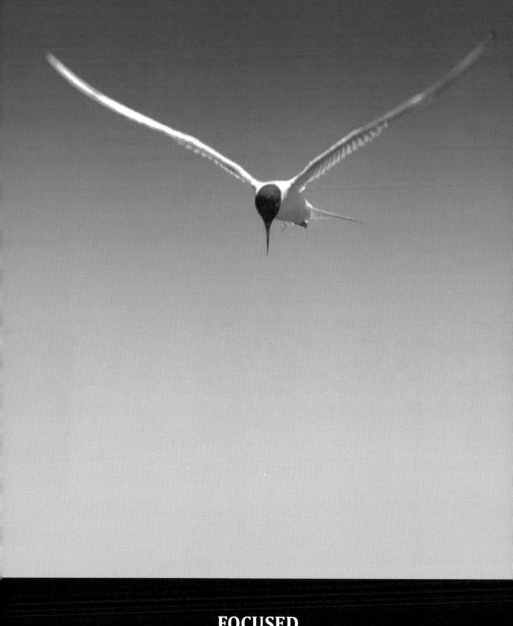

FOCUSED

EVERY nerve end is focused.

see, hear and sense every movement.

can attack at any second.

'm ready with every fiber of my being. That's my day

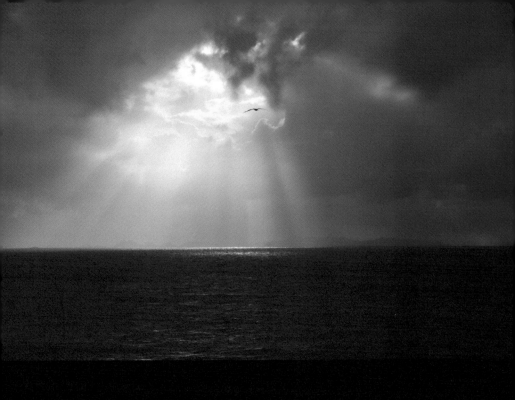

DARKNESS

DARKNESS...a deep blackness that snuffs out my conscious self, carrying me to a pit that engulfs my spirit.

I'm in a hole so deep no one can reach me.

The pressure of the void squeezes with a force beyond reasoning.

It's only when LIGHT trickles in through a touch, voice, or look that I begin to see.

I scream "LET THERE BE LIGHT!"

USE WHAT YOU HAVE

The Vietnamese were very creative people.

Creativity is part of living in a third world country.

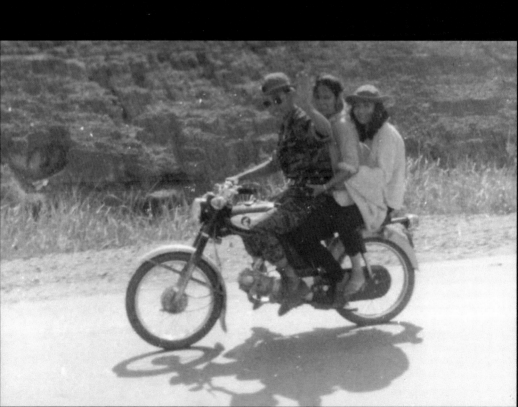

WHAT EVER IT TAKES TO GET TO WHERE YOU'RE GOING

Two Vietnamese boys in rual Saigon on water buffalo

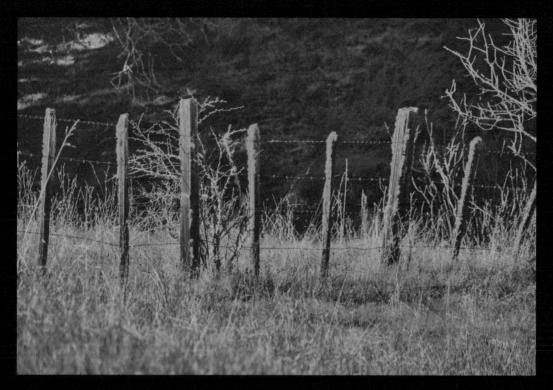

FENCES

FENCES...do they maintain order or hem me in? I feel trapped to my past memories that reap the whirlwind upon me.

Once I bring back the unconscious memories I fear the rage that festers inside.

Who the hell wants to unleash a tornado that spins out of control mowing down everything in its way?

 I can taste it and part of me wants to chew on the sour poison that swells my lips causing me to choke on it.

FEW know how close to the edge I sometimes live.

I'm learning containment is a good thing for me. My boundaries help me pace myself even stopping when I need to because I'm the expert about me. NO one comes close.

I'm learning to trust my feelings and spill tears—those salty cascading water drops oozing out my pain.

FENCES, I think I need them.

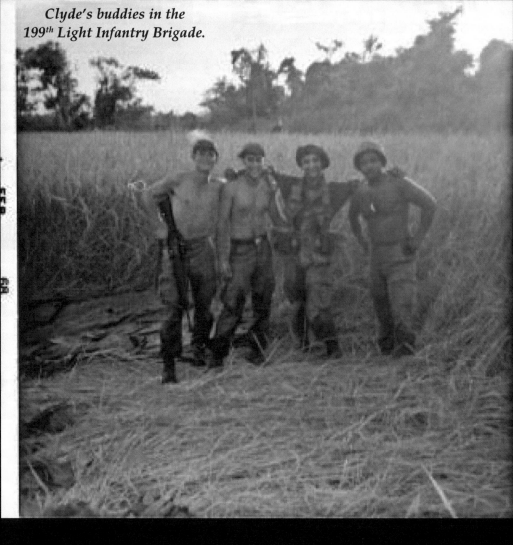

Clyde's buddies in the 199th Light Infantry Brigade.

NAMES

WE smelled death together.

We felt bullets scream toward us, grenades exploding around us as we crawled toward the enemy wanting nothing more than peace.

For me, more than 40 years after the fact I see you in my dreams and feel guilty that I can't remember some of your names.

BARBED WIRE

I have the best of intentions but it doesn't last.
That deadly barb begins to do its work. It can draw blood.

Someone gets too close or they ask my opinion and receive brutal
honesty, you know, the kind that isn't nice but the truth.

They asked for it didn't they?

They came close and got pricked. What do they expect?

I'm barbed wire and I can hurt others. "I don't give a damn," I say
but I'm not sure this is the way I want to continue to live my life.

GOLDEN RAY...

Glimpses of hope penetrate my presence.

I refuse to give up, allowing the golden rays to deepen my quest.

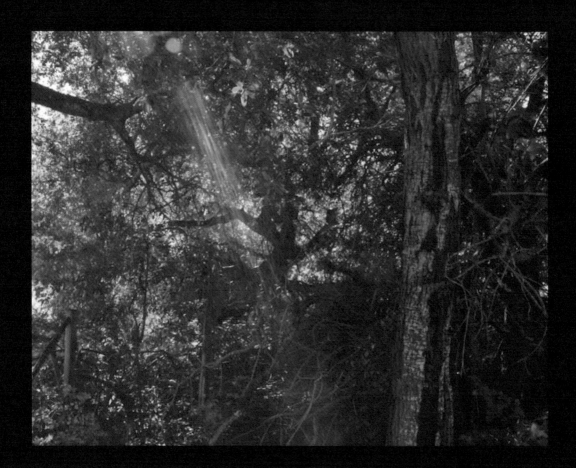

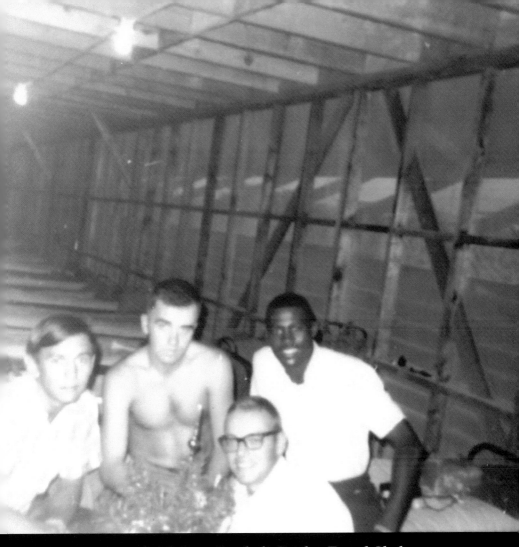

(L-R) Pete, Zamboli, Booker T. and Clyde celebrating Christmas 1968 at base camp.

CHRISTMAS CARE PACKAGE

We received a care package with a silver Christmas tree — it helped

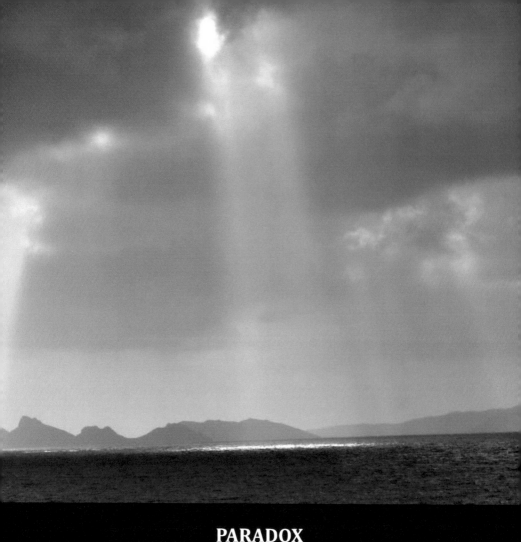

PARADOX

HOW can I be back reliving what I prayed I would never have to do
again?

WHY does the nightmare bounce around my cerebellum repeating
the horror of it all?

HOW can a sneak attack hit me without notice? How can I be happy
and have that taken away in an instant?

I'm present and before I know what's happened I'm transported
against my will to repeat memories I keep trying to forget.

WHAT I'm learning is a paradox:
in order to forget I must remember.

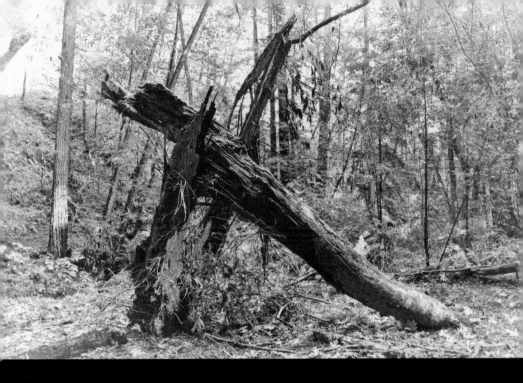

BARELY HANGING ON

I try to stand by myself.

There are so many of us who do this.
Yet, I am close to crashing to the ground.

Is it a matter of trust, control, obstinacy, or ego?

Whatever the case, I think I could use some help.

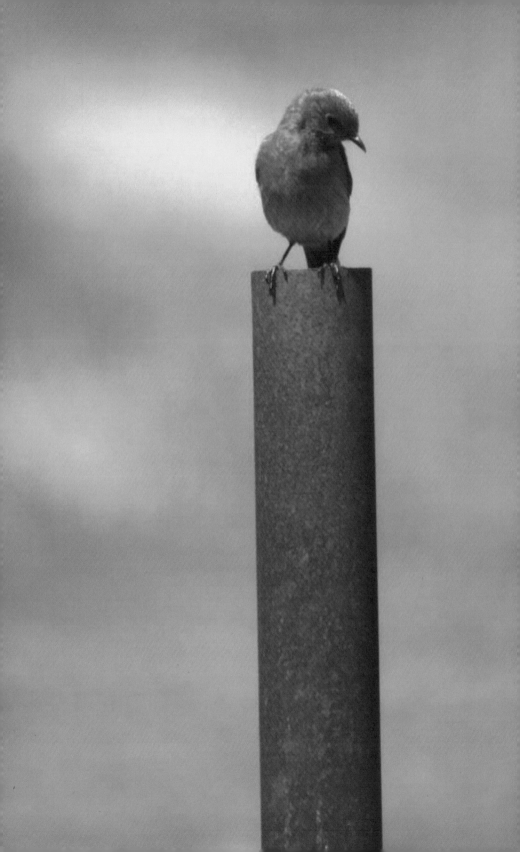

LONELY BIRDS

We are lonely birds.

Our wings have been clipped and we sit on rusty poles pondering.

We sit alone even when loved ones surround us.

We turn our heads rather than look too deeply.

Avoidance, isolation, inner torment is our companion.
Some of us will die this way.

YET deep within, awakening is possible. We know the darkness, images, grays, and lack of light doesn't work.

We want more but suffering calls our name. It's a companion that doesn't treat us well. The haunting pain isn't living.

Color does exist.

Look at the lonely blue bird. There is a beauty to it.

A song is hidden inside; the wings grow back similar to the journey that took them away.

The new journey has a voice based on the insight that no one deserves to be captive to the shadow side.

WE fought for freedom. We deserve to be free.

We deserve to forgive ourselves.

We are lonely birds who can fight the good fight and FLY...

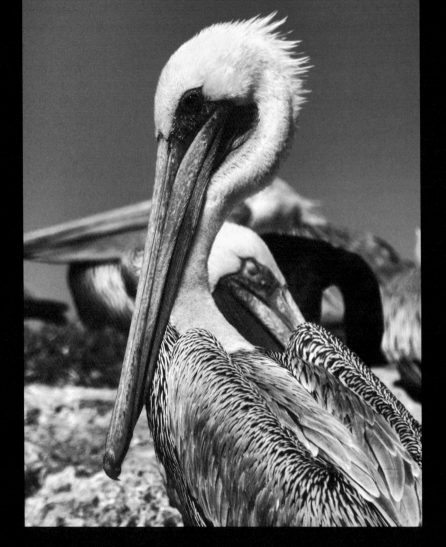

MY PAST, PRESENT AND FUTURE COLLIDE

I find myself engulfed with a mixture of intent and lack of identity.

I look at myself finding few answers and lots of questions.

My soul seems small at times and I so desperately want to love but even the word scares me.

I think I might be part of WHO I used to be, WHO I currently am, and working on WHOM I want to become.

It's a process and I'll take all the company that cares to join me.

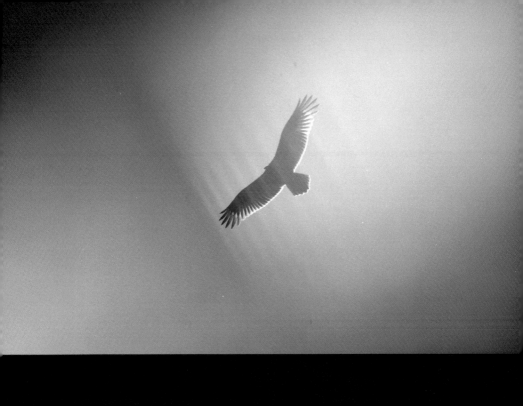

SILENCE

TEARS

TEARS aren't easy for me.

They give me relief but they are so hard to produce.

To go that deep, to penetrate the layers, to open up the numbness,
to let the feelings surface...
well, let them flow.

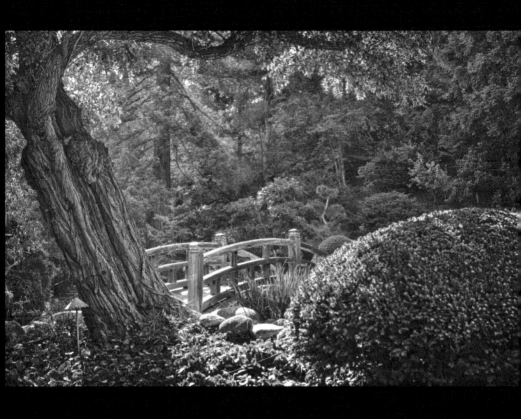

CROSSING THE BRIDGE

I want to cross to the other side.

Is it fear, anxiety, depression or am I a coward?

I've fought the fight, my battle scars, my dreams, my moment's...
can I take a step and cross that bridge?

I'm CLOSE...

come on,

one step at a time...

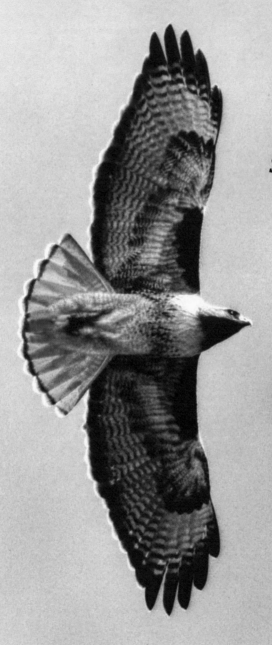

Spread My
Wings &
Soar.

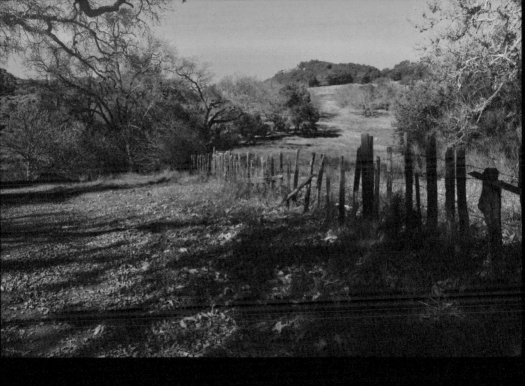

ORANGE SKY

Splashes of orange as the sun goes down...

my heart is joyful.

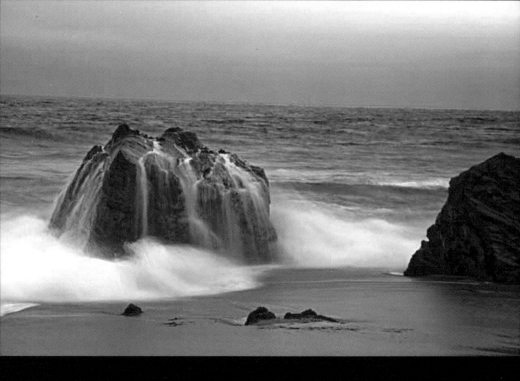

NOT ALONE

MY emotions can spill over at times. I'm learning to control them by thinking before reacting.

My gut is the first thing that gets hit when I feel threatened. A PAUSE can do wonders.

FINDING AND DOING SOMETHING I enjoy is a healing agent.

I'm learning to carry around a tool chest full of options.

Talking to someone helps, medication, having friends, embracing a hobby, avoiding negativity.

Realizing I'M NOT ALONE makes a connection I need.

SHALL WE JOURNEY TOGETHER?

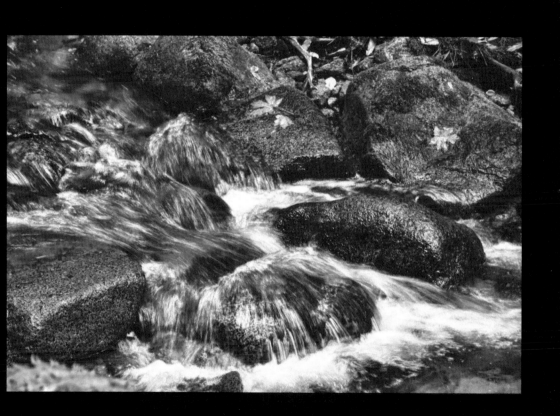

MOVEMENT

Life isn't meant to be static...

FEB 68

BOOKER T. — MY BUDDY

Soldiers live together under intense situations.

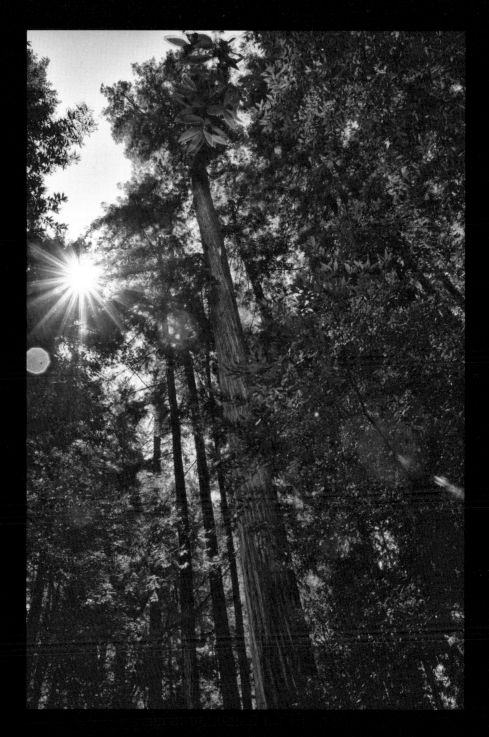

STARBURST

LIGHT takes away the darkness.

I seek it, allowing it warm me.

I become healed for the day.

SEARCHING

Sometimes the light hides from me.

It's diffuse.

It's often hidden among the tall trees so I go to the forest and find it.

My kind of therapy.

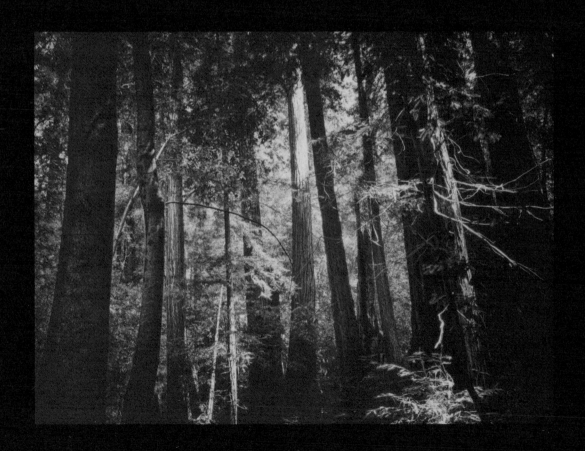

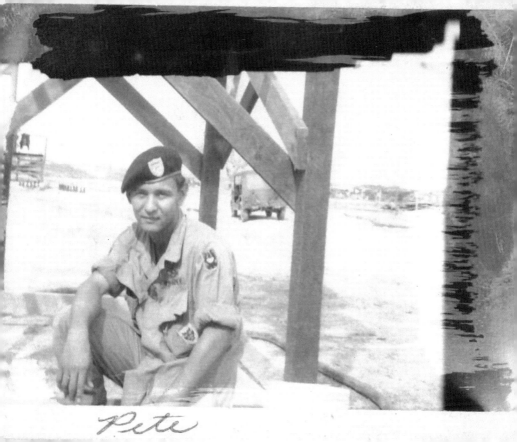

Pete

nbol of the cross on the medical chopper could bring
vounded.

er, the symbol was also a "bulls-eye" to an enemy who
asy target, often shooting it down.

vas never a safe place in war.

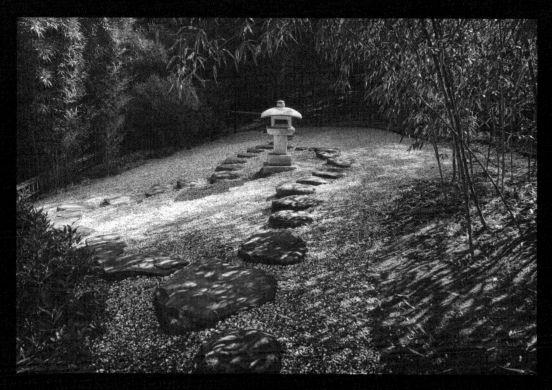

SILENCE—AN EXERCISE

Breathe in deeply...
Center yourself...
Look around and let your senses activate.

Listen, look and smell.

If you are near bamboo or a bamboo tree, touch it. Notice the texture while taking in the strength of its nature.

Listen to the beat of your heart. Be thankful for the life that flows through you.

Notice how the quiet provokes introspection. Feel your thoughts.

Look at the pagoda and see how simple it is—yet beautiful.

The footstones lead you to openness. Let go of the inner clutter and let simplicity wash over you.

Stand, sit, or kneel. Spend some moments as you feel a cleansing occur.

When you are ready—leave. *You have just touched the hand of God.*

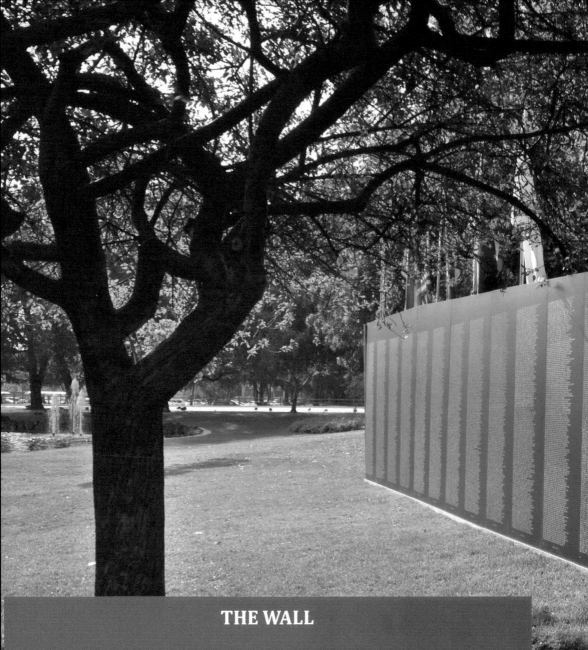

THE WALL

Holding my breath as tears cascade down my face, I look at the shimmering wall aware that I'm choking up. I can't swallow; I'm hot, my skin feels clammy deepening my sense of tension. Wow, this is tough! I see their names. I fought along side these soldiers who died next to me. My heart is heavy as sadness envelops me.

I WILL NEVER FORGET.

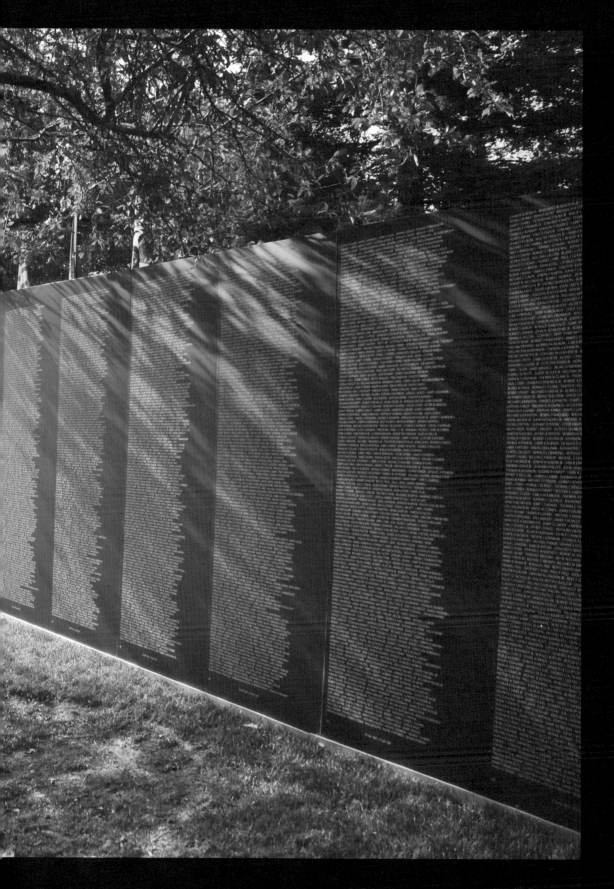

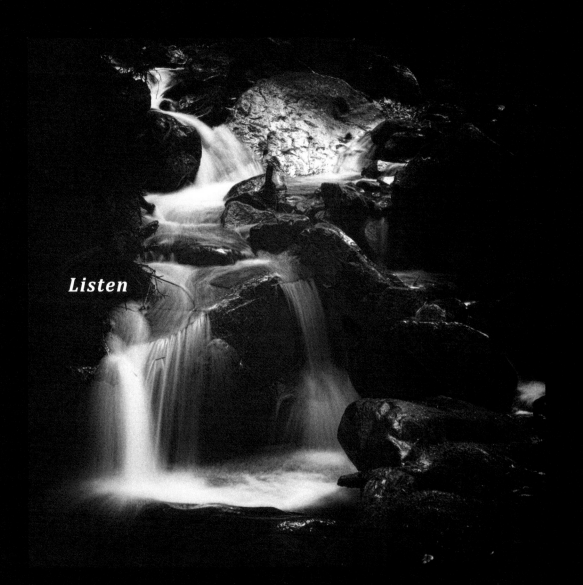

Listen

THE JOURNEY

I've traveled many roads. This journey is a historic one.

My pilgrimage has generations of soldiers who have led the way.

Many have stayed the course facing adversity, fighting the demons that seek to destroy.

I am one of the millions yet I am an integral part of the history of each soldier.

I, as well as you, am a survivor!

ABOUT THE AUTHOR/PHOTOGRAPHER

Clyde R. Horn is a retired licensed psychotherapist and combat veteran of the Vietnam War (1967-68) He is the recipient of the Combat Infantry Badge, Purple Heart and Army Commendation Medal. He was in Nam during the TET offensive. Clyde is an amateur photographer who uses his photography as form of therapy. Friend him on Facebook at facebook.com/drhorn. Clyde is married, has children and grandchildren.

Clyde began to have PTSD symptoms after retiring from full-time work. He participated in group and art therapy through his local Veterans Administration. He and some of his fellow PTSD buddies: Alex, Mike, Larry, Zak and James have breakfast often, supporting one another with stories, laughter, food and understanding. This book is part of their experiences and input.

RESOURCES

WEB SITES

VA HOME PAGE...................www.va.gov

VA Forms...............................www.vagov/vaforms

VA Facilities..........................www.va.gov/directory/guide/home.asp

Returning Veterans............www.seamlesstransition.va.gov

General newslettermilitary.com

PHONE NUMBERS

VA Benefits............................1-800-827-1000

Education...............................1-888-442-4551

Health Care...........................1-800-697-6947

CPSIA information can be obtained
at www.ICGtesting.com
Printed in the USA
256593LV00004BA

9781611700558